COLOR
NEW YORK

D1405015

HARPER DESIGN

An Imprint of HarperCollins Publishers

Color New York

Illustrations copyright © 2016 by Emma Kelly.
Design and layout copyright © 2016 by The Ivy Press Limited

All rights reserved. No part of this book may be used or
reproduced in any manner whatsoever without written
permission except in the case of brief quotations embodied
in critical articles and reviews. For information address
Harper Design, 195 Broadway, New York, New York 10007.

HarperCollins books may be purchased for educational,
business, or sales promotional use. For information please email
the Special Markets Department at SPsales@harpercollins.com.

Published in 2016 by
Harper Design
An Imprint of HarperCollins*Publishers*
195 Broadway
New York, NY 10007

Tel: (212) 207-7000 Fax: (855) 746-6023
harperdesign@harpercollins.com
www.hc.com

Distributed throughout North America by
HarperCollins Publishers
195 Broadway
New York, NY 10007

ISBN 978-0-06-244509-4

Library of Congress Control Number: 2015949979

Printed in Canada

Third Printing, May 2016

This book was conceived, designed, and produced by
Ivy Press
210 High Street, Lewes, East Sussex BN7 2NS, UK

THIS BOOK
BELONGS TO

..

..

..

..

..

COLOR
NEW YORK

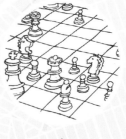
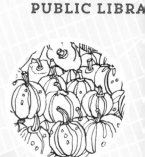

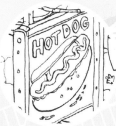

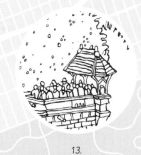

13.
CENTRAL PARK

10.
HOT DOG CART

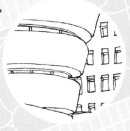

8.
THE HIGH LINE

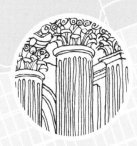

7.
THE GUGGENHEIM
MUSEUM

17.
THE METROPOLITAN
MUSEUM OF ART

19.
TIMES SQUARE

9.
GRAND CENTRAL
STATION

11.
THE NEW YORK
SKYLINE

INTRODUCTION

With almost as many nicknames as it has skyscrapers, New York has never been shy about its attractions. Alongside some of the most recognizable buildings in the world, "the city that never sleeps" also has some of the busiest and liveliest streetlife—it's all captured here in a virtual trip around the city, ready for you to color in and make your own. *Color New York* offers twenty New York vistas, every one with dozens of carefully recorded details to ponder while you color, such as the architectural finesse of the New York Public Library.

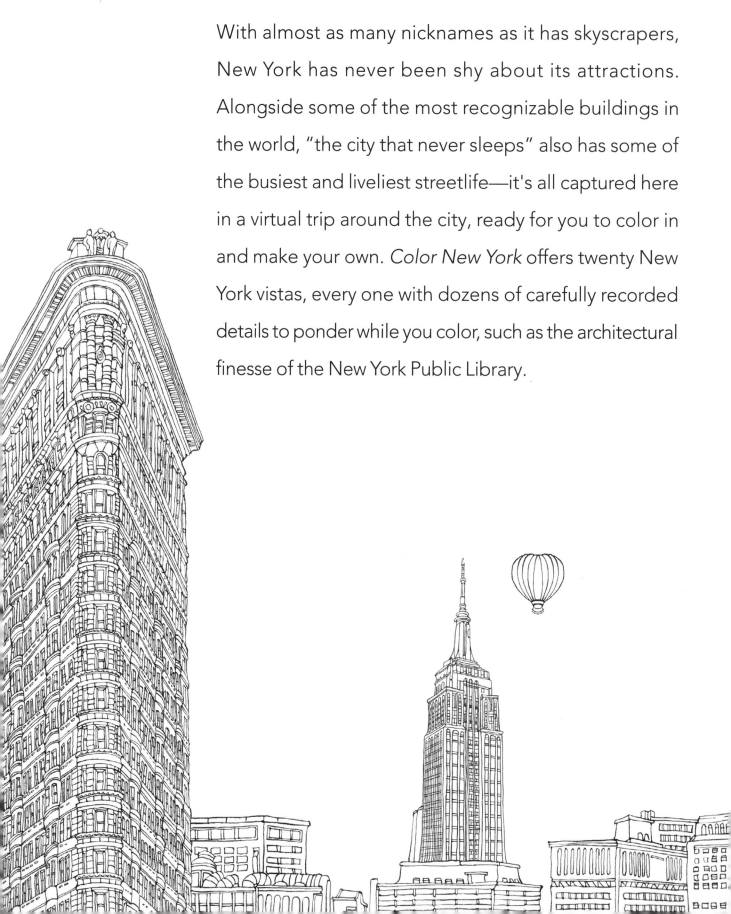

From the chess players of Washington Square Park to the Wonder Wheel of Coney Island, this coloring book encourages you to take in every aspect, large and small, of the vast range of the city's sights. Enjoy the sheer range of the homegrown produce at the Union Square Greenmarket, relish every flag and banner as you visit Little Italy during the annual Feast of San Gennaro, and admire the elegant lines of the Guggenheim Museum. New York has brought the pictures: all you need to bring are the colored pencils.

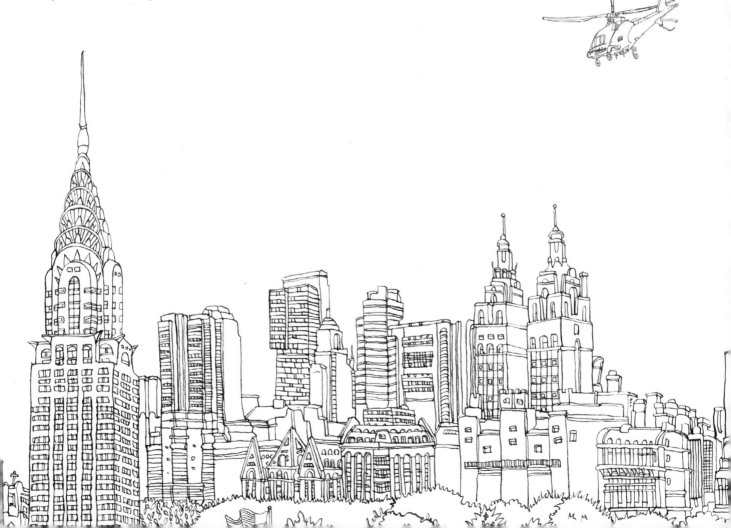

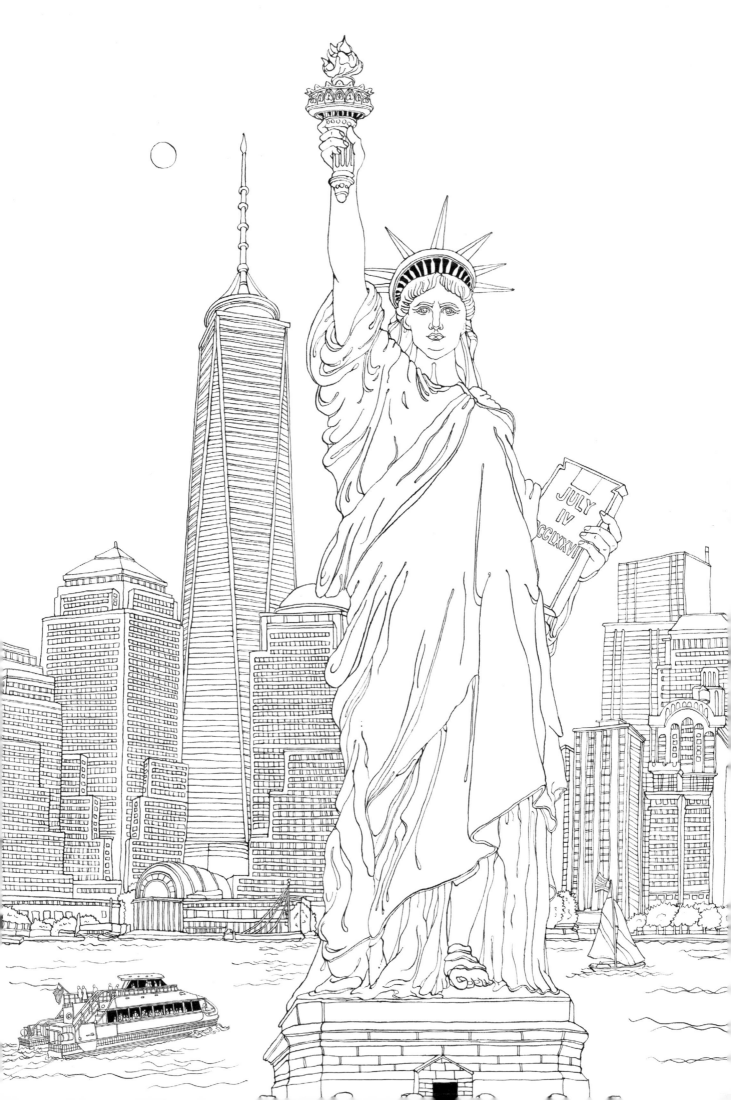

previous page

1.

NEW YORK HARBOR &
THE STATUE OF LIBERTY

Liberty, the quintessential symbol of America, was a gift from France, conceived as a homage from one great liberal nation to another. She was designed by the French sculptor Bartholdi in the 1870s, using more than 200,000 pounds of copper, and was exhibited in pieces (her torch-bearing arm in Philadelphia and Madison Square Park in 1876, and her head at the Paris World's Fair in 1878) before she was finally unveiled, complete, on her island in 1886. She still dominates the harbor, although many taller landmarks—such as the One World Trade Center tower seen here on the Lower Manhattan skyline— have gone up in the 130 years since her arrival.

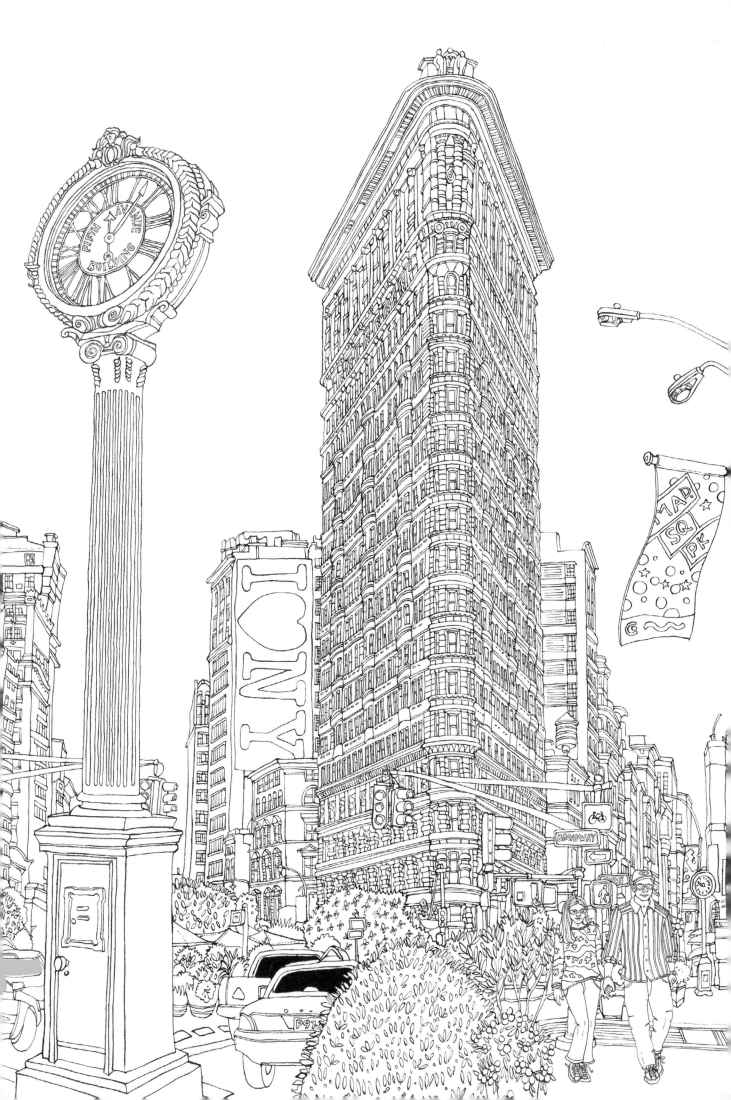

previous page

2.

THE FLATIRON BUILDING AT FIFTH AVENUE & BROADWAY

"I was thinking of securing this as a winter residence, but had to give up the idea, because the rent was higher than the house" quipped Mark Twain about the Fuller Building soon after it opened in 1903—before it was colloquially rechristened. Critics of the groundbreaking skyscraper said that it would certainly fall down, while the strong crosswinds created by its pie-wedge shape and corner plot attracted groups of loitering boys hoping to see a glimpse of ankle—or more—as the skirts of passing ladies flew up in the draft. Today the well-loved city landmark is accepted as one of the Beaux Arts masterpieces of New York.

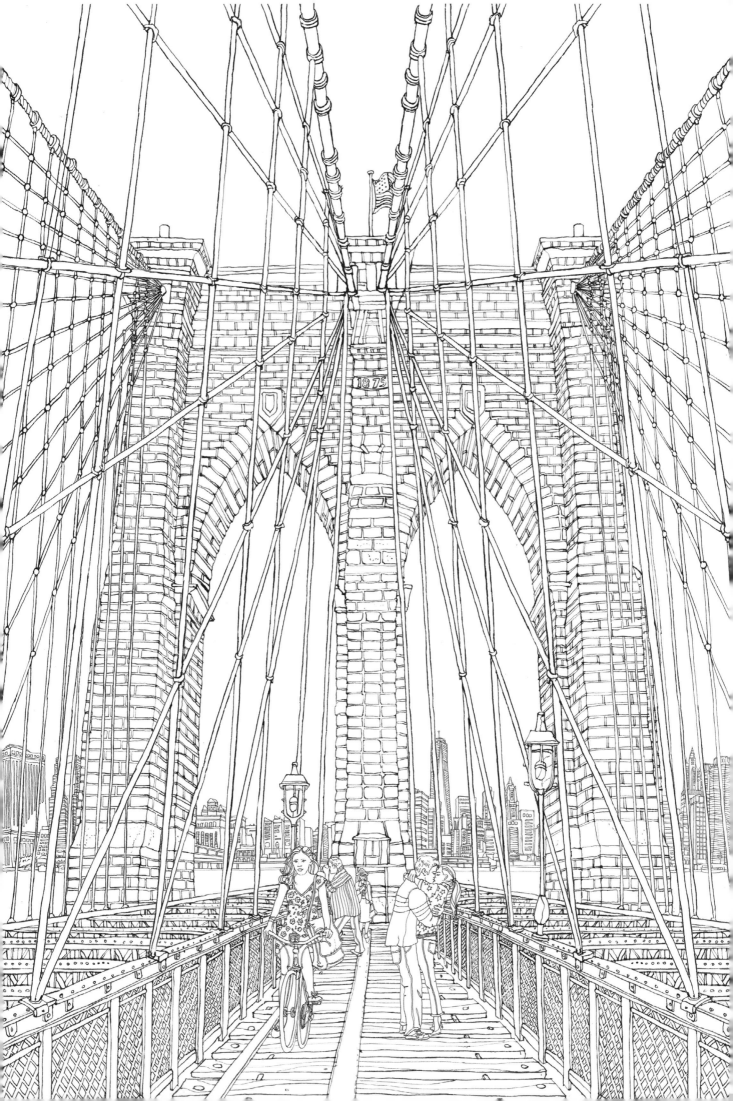

previous page

3.

BROOKLYN BRIDGE

When it opened in 1883, the Brooklyn Bridge over the East River was the longest suspension bridge in the world, and was a cutting-edge feat of engineering—although it came at some cost. It took more than a dozen years to build, and at least twenty people are believed to have died in accidents during its construction, including its original designer, John Roebling. Washington Roebling (John's son) took over the work with his wife, Emily, who was the first person to cross the bridge on its triumphant completion. More than 130 years later, it's still going strong, and is used by 120,000 vehicles, 4,000 pedestrians, and 3,000 cyclists every day.

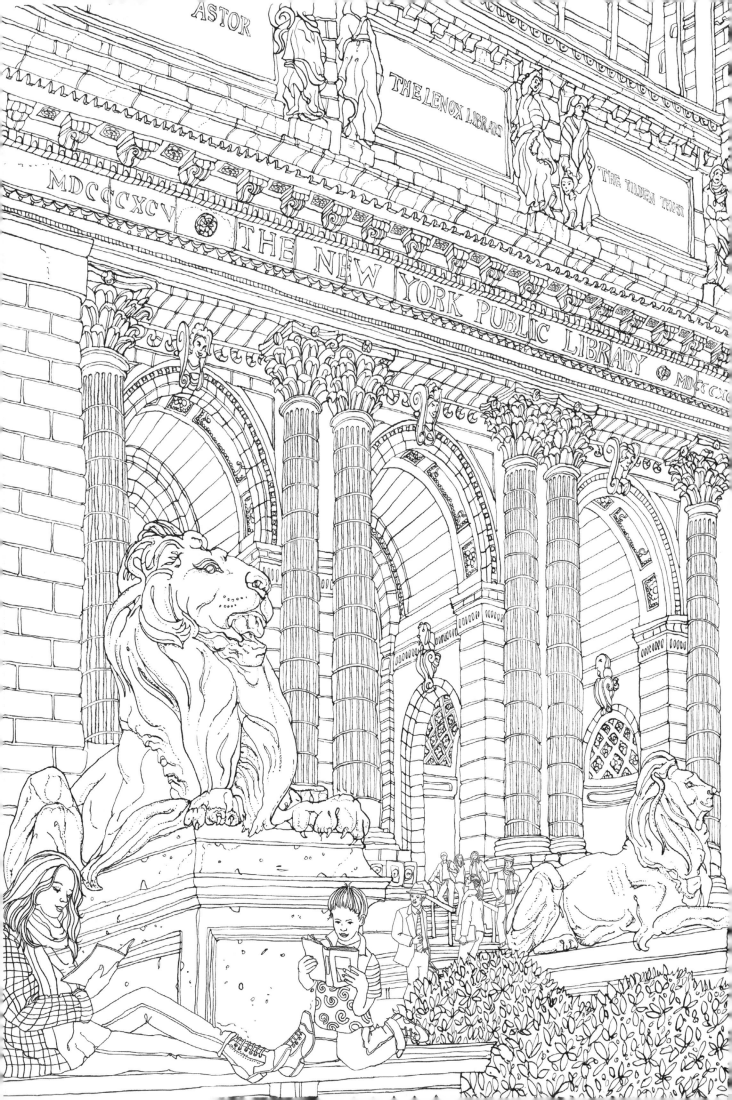

previous page

4.

THE NEW YORK PUBLIC LIBRARY

For those who like their public buildings imposing, the New York Public Library doesn't disappoint. The building on Fifth Avenue at 42nd Street was opened in 1911, combining two previous collections, both financed by wealthy philanthropists: the Lenox Library, farther down Fifth Avenue, and the Astor Library, originally in the East Village. The grandiose new porticoed building, with lions guarding the entrance, had more than seventy-five miles of shelves, although by the 1980s the collection had outgrown even this huge space, and an underground extension was created beneath Bryant Park.

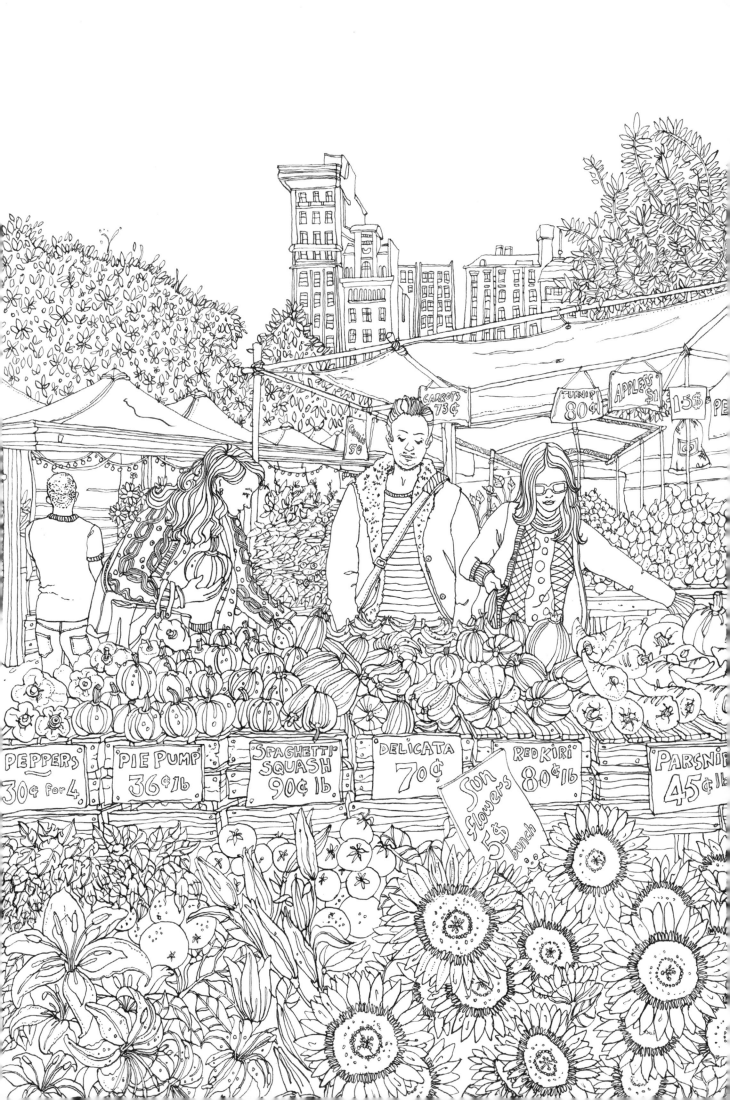

previous page

5.

UNION SQUARE GREENMARKET

The Greenmarket movement began in 1976—its first outing consisting of just twelve stalls in a parking lot—with the aim of bringing fresh, local produce directly to New Yorkers. Union Square Greenmarket is now the best known and largest of more than fifty markets in the city, and is held four days a week: Mondays, Wednesdays, Fridays, and Saturdays. Busy, colorful, and dynamic, the market is the best way to enjoy the sheer variety of local products, both ordinary and exotic, from honey and buffalo steaks to squashes and cider.

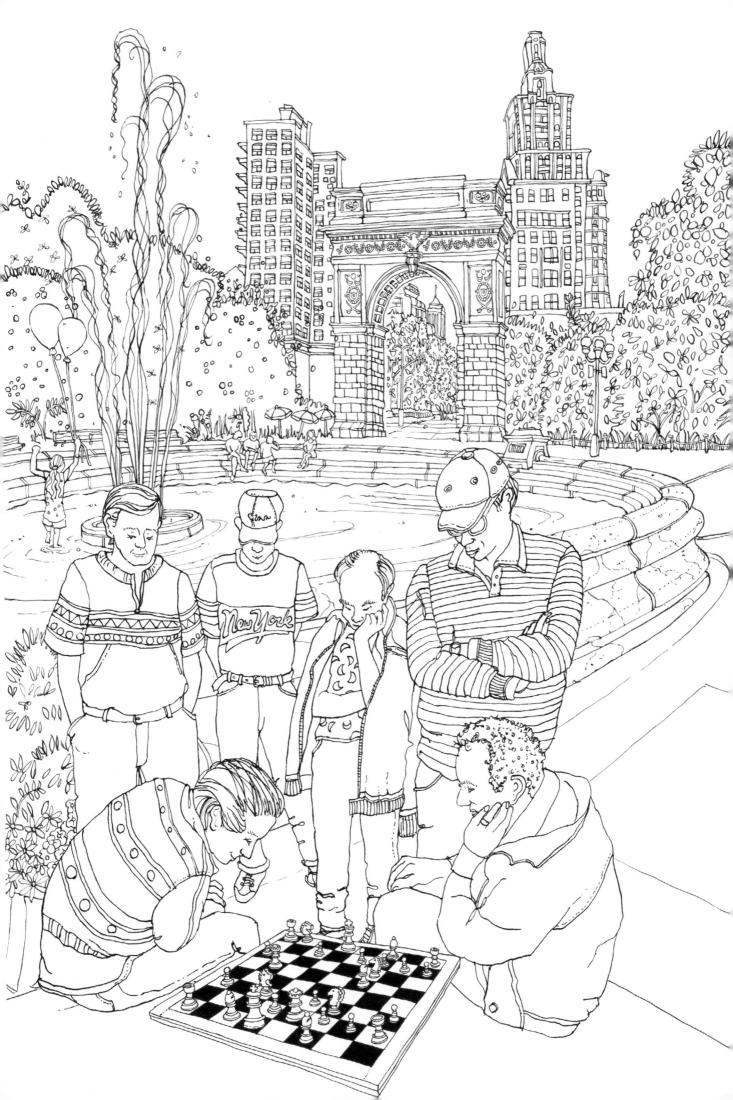

previous page

6.

WASHINGTON SQUARE PARK

Built on the site of an old burial ground, Washington Square Park was created in the nineteenth century as a green space for residents in what was becoming an increasingly desirable area to live. Its famous arch, designed by the renowned architect Stanford White and modeled on the Arc de Triomphe in Paris, was completed in 1892, replacing a simple wooden predecessor that had been built to mark the centennial of George Washington's presidency. Today the park remains a popular meeting spot for everyone from chess players to buskers.

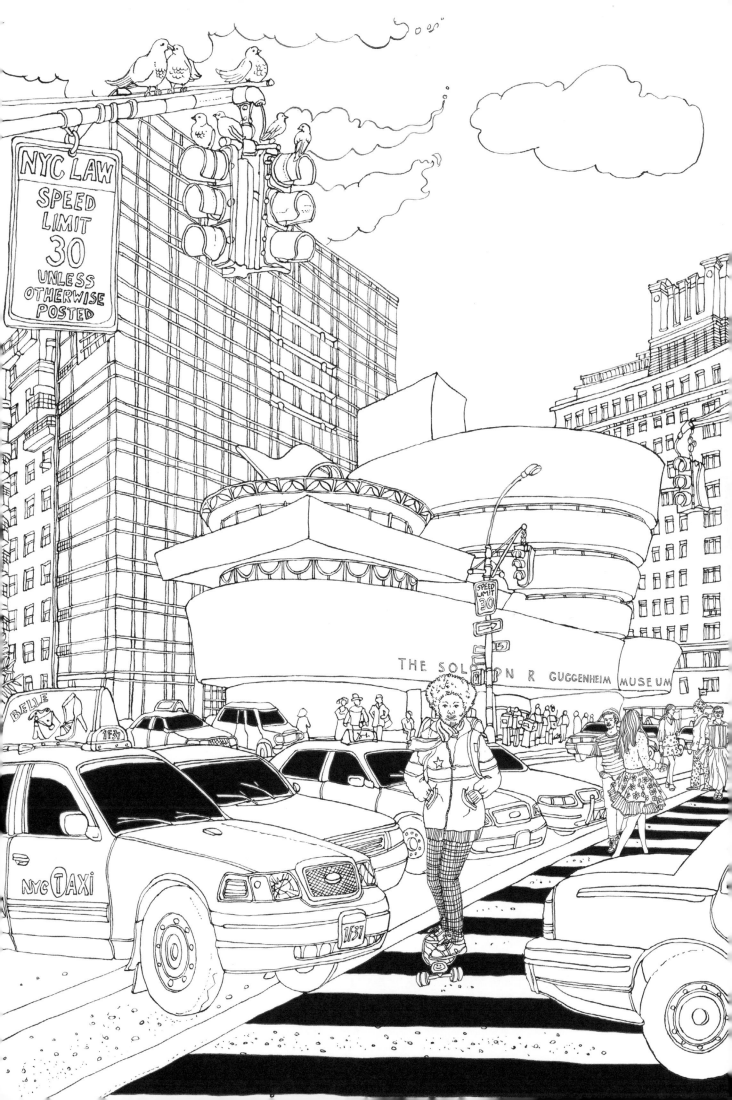

previous page

7.

THE GUGGENHEIM MUSEUM

Likened to a snail shell or an inverted ziggurat, Frank Lloyd Wright's Guggenheim Museum gained the status of architectural icon not long after its completion. The museum was commissioned by Solomon R. Guggenheim in 1943 to house his collection of modern art, but at several points it seemed that it would never be built. Wright famously produced 749 drawings for the project, with endless modifications, but both men died before the museum was finally completed in 1959. Wright's final design, which funnels visitors from the top of the museum down a long, spiral corridor, created the idea that a building may contribute as much to the museum experience as the art itself.

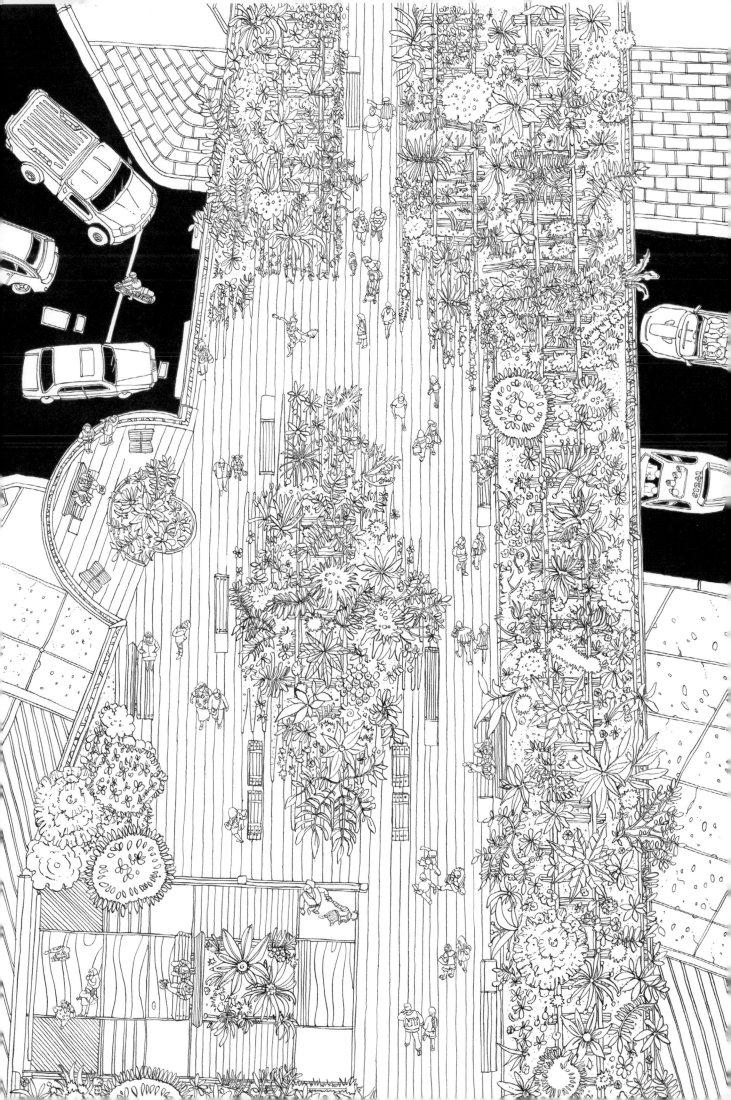

previous page

8.

THE HIGH LINE

The High Line started life as an elevated railway, carrying freight trains from 34th Street to St John's Park Terminal at Spring Street. By 1980 it had become redundant, but was saved from demolition for use as a community space. A competition to decide on the best use for the line eventually fixed on the idea of a public park running high above the city streets for almost one-and-a-half miles. When the first section opened in 2009 it was an immediate success, with the characteristically airy "drift" planting of Dutch garden designer Piet Oudolf giving the park much of its natural look. The third and final section opened in 2014.

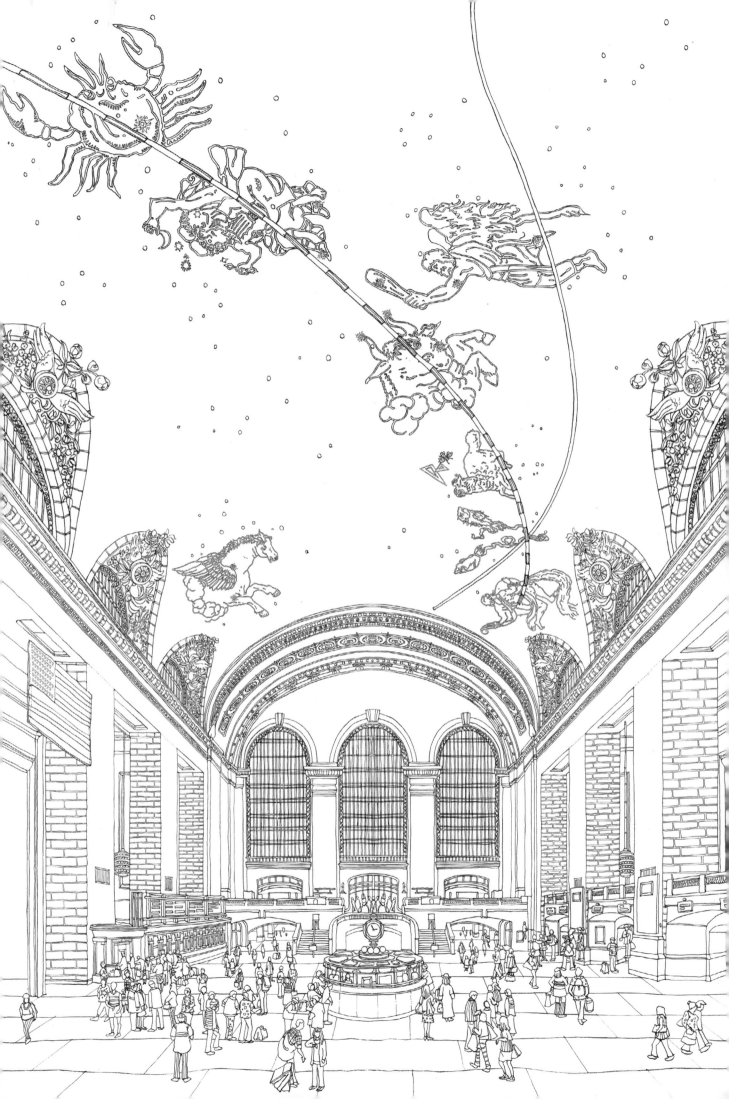

previous page

9.

GRAND CENTRAL STATION

The Beaux Arts exterior of Grand Central Station (properly known as Grand Central Terminal) is impressive enough, but inside the sheer scale of the concourse is breathtaking—vast enough to dwarf the many people rushing to and fro. Look up to the huge vault of the ceiling and you'll see a sky's worth of gold-leaf constellations against a cobalt-blue background—the work of the French artist Paul César Helleu in 1912. Look a while longer and you may notice that some constellations are painted the wrong way around, but it would be churlish to complain when the effect is so grand.

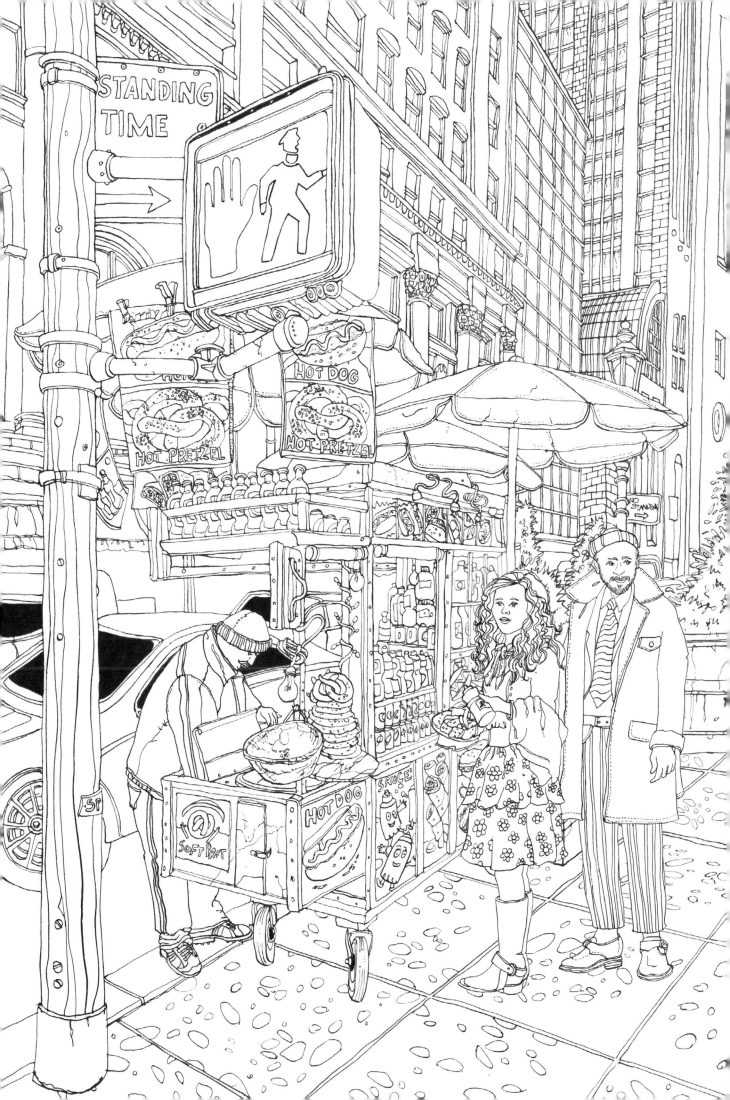

previous page

10.

HOT DOG CART

The classic hot dog cart is a popular year-round fixture on New York City sidewalks. The menu isn't usually extensive—hot dogs, salty pretzels, soda or water, with the occasional snow cone on hot summer days—but there's something comforting about the unchanging list. Popular locations, particularly outside major tourist attractions, are both sought after and expensive; one spot outside the Metropolitan Museum of Art hit the headlines when the news came out that the rent was more than $50,000 a month—which adds up to a lot of hot dogs.

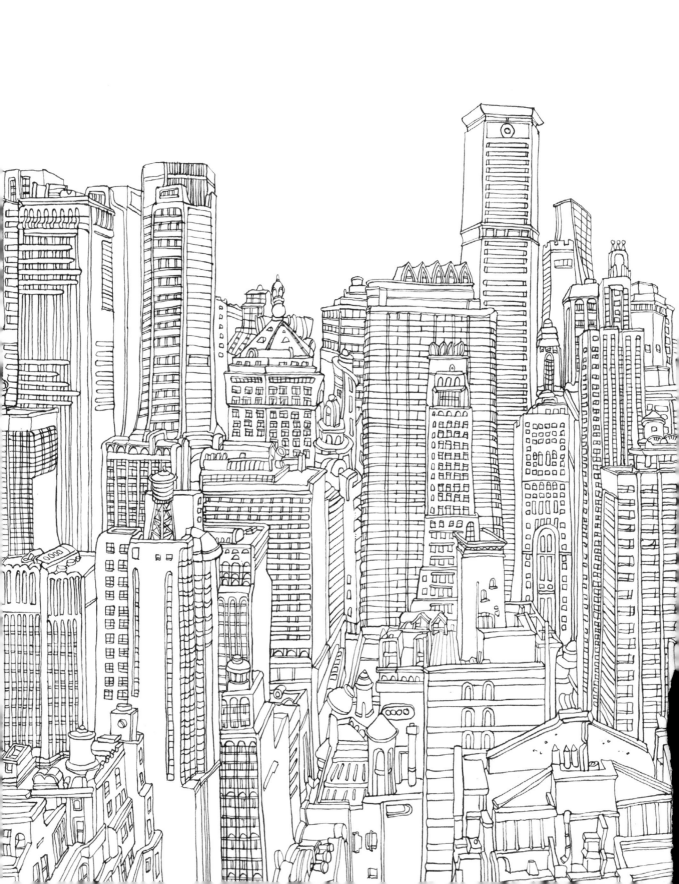

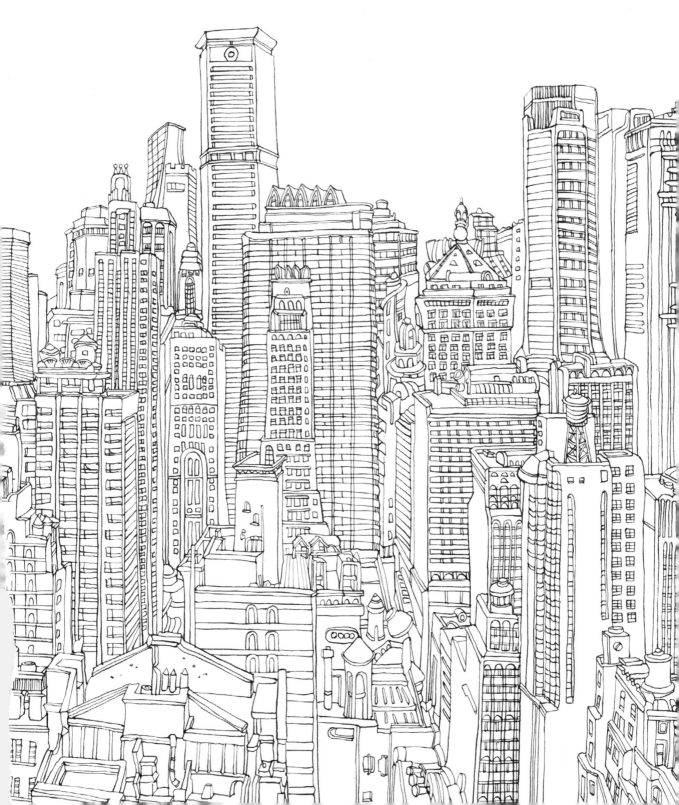

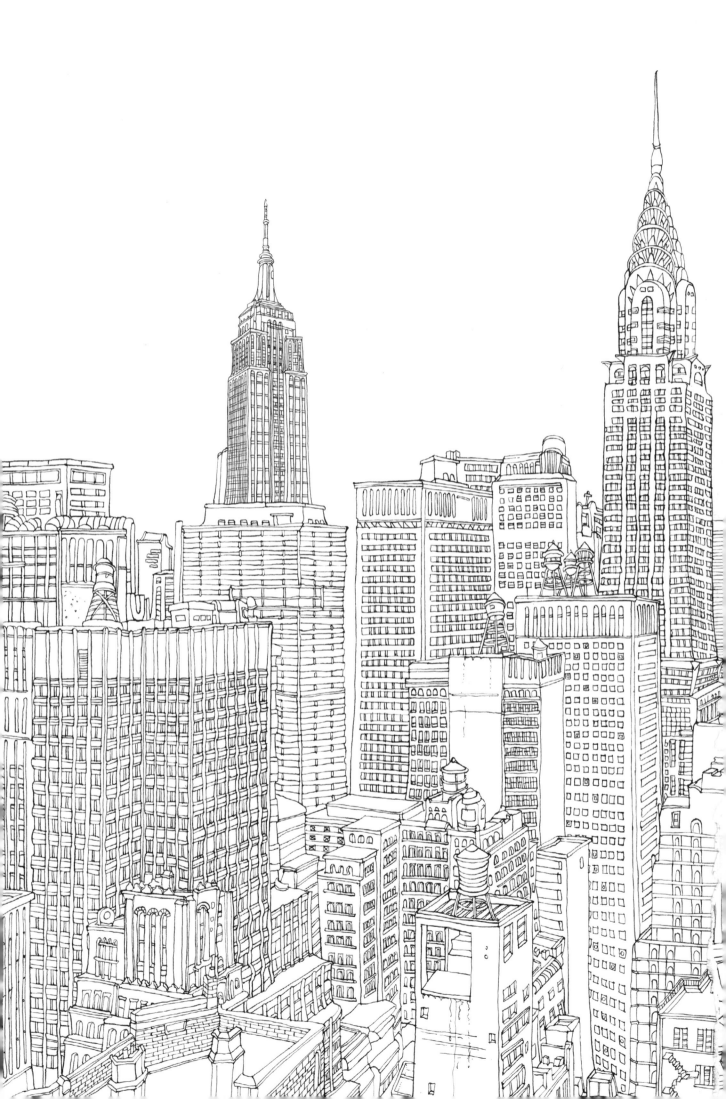

previous page

11.

THE NEW YORK SKYLINE

New York has always been famed for its skyscrapers. The canyon effect that you can feel walking along the streets of Manhattan disappears when you view the city from above, and the extraordinary quality of its high-rise architecture makes itself felt. Whether you're gazing uptown toward the Art Deco Chrysler Building and the iconic Empire State Building—it was the tallest building in the world until 1970—or taking in the views from the latter's 86th floor observation deck, New York from above offers a completely different perspective.

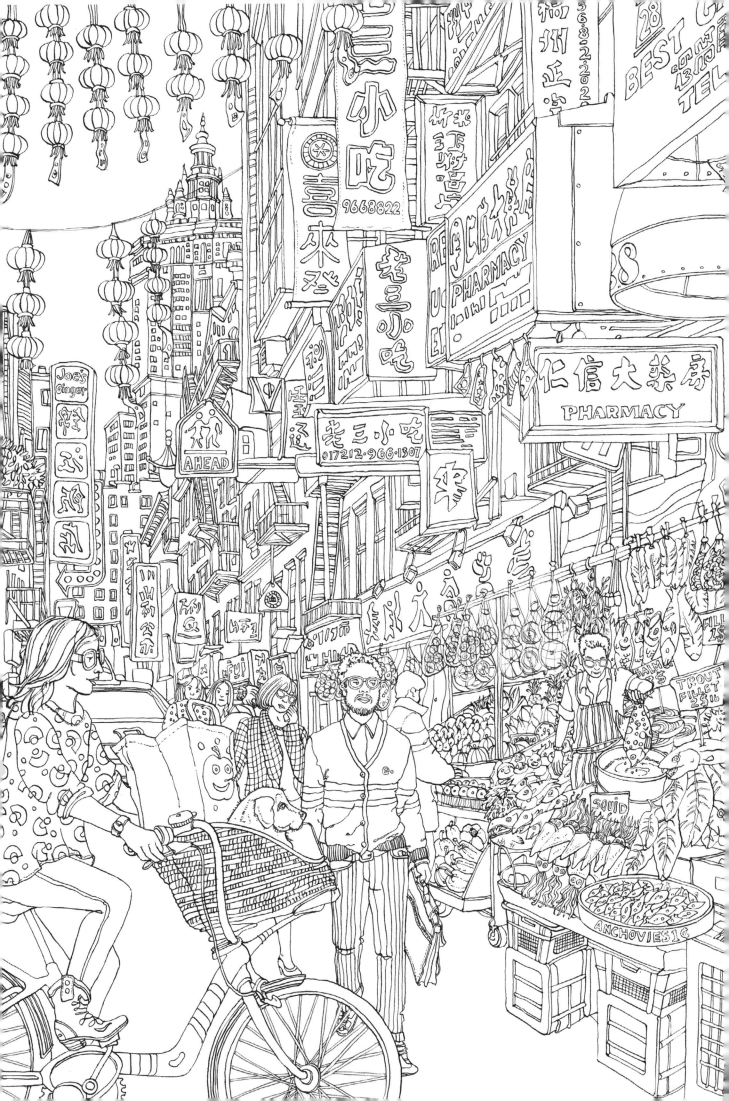

previous page

12.

CHINATOWN

With Little Italy directly north and Tribeca and SoHo to the
west, Chinatown is a crowded, compact area in Lower Manhattan.
There's been a small Chinese population here from the mid-
nineteenth century, but after immigration restrictions were lifted
in the 1960s it rapidly grew much larger. Today, visitors pour into
the district, shopping for everything from bean curd and snow crabs
to bok choy and herbal remedies, or simply stopping off for bubble
tea or dumplings at the hundreds of restaurants and cafés.

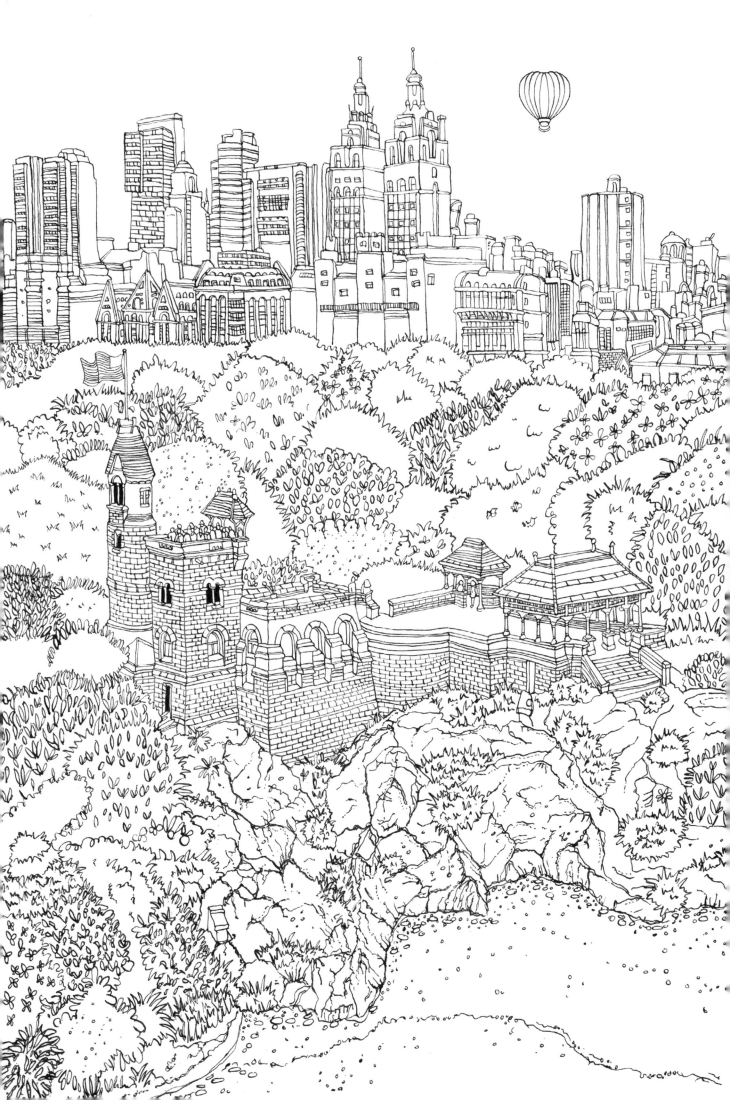

previous page

13.

CENTRAL PARK

One of the most famous parks in the world, Central Park is full of attractions, but the Belvedere Castle, a whimsical and elaborate building perched on Vista Rock, alongside the 79th Street Transverse, must be one of the most eccentric. It was designed as a Victorian folly by Calvert Vaux, one of the park's original designers, to take advantage of the highest and best view in the park. Today it is one of Central Park's five visitor centers and a popular bird-watching site—kestrels and even the occasional osprey have been spotted from its viewing platform.

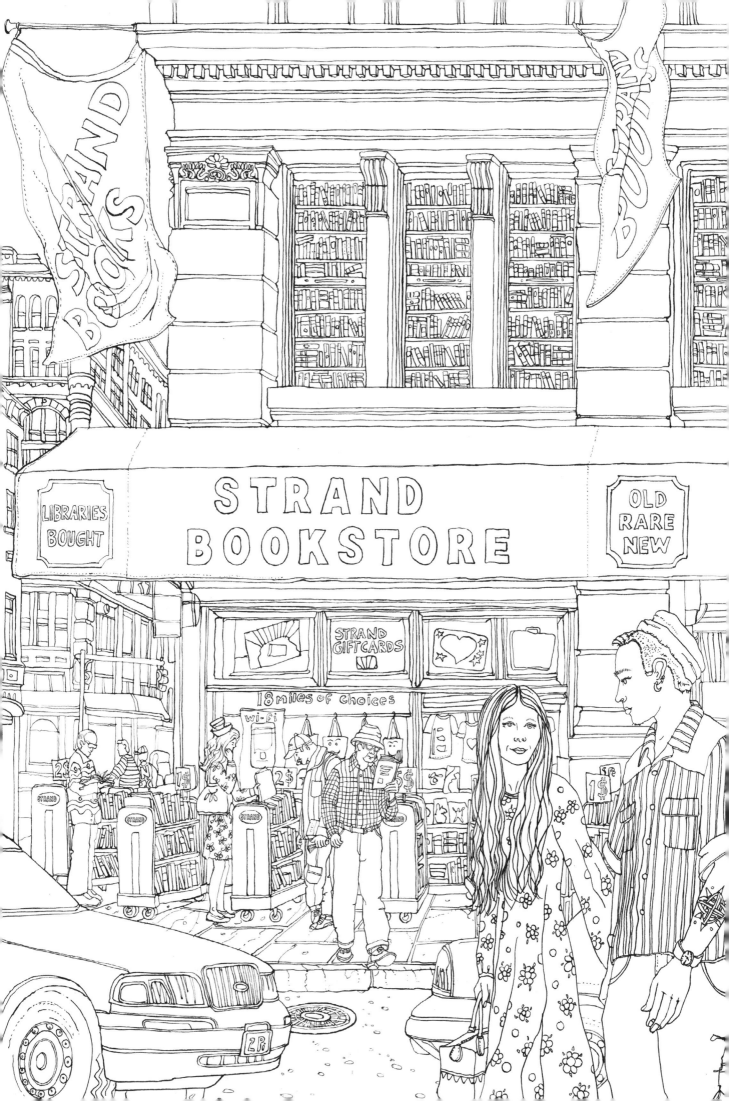

previous page

14.

STRAND BOOKSTORE

"18 Miles of Books" must be the best slogan ever coined for a
bookstore. And it's not the only neat thing about this legendary
eighty-eight-year-old independent bookstore in the East Village,
which has remained in the same family since it was opened by
Benjamin Bass in 1927. At a time when online book buying is on the
rise, the Strand has triumphantly bucked the trend, with constantly
fresh marketing ideas, a supply of books-by-the-yard, a service that
puts together custom-curated shelves, and a huge range of books
that spills out onto the sidewalk.

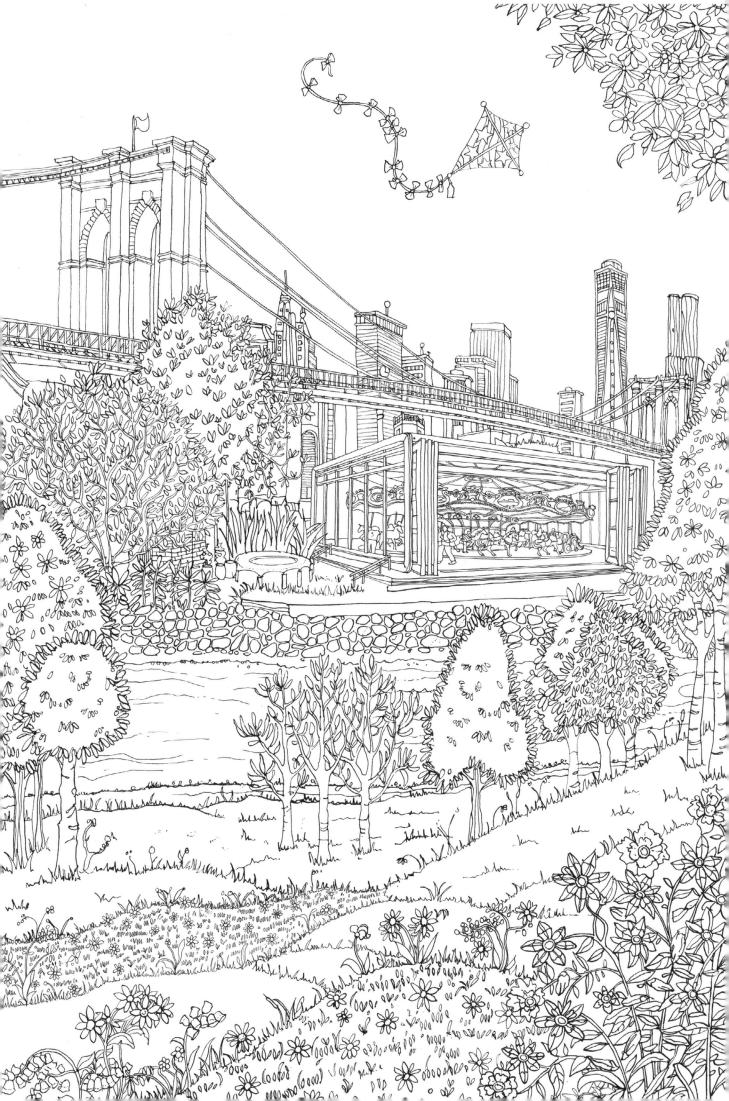

previous page

15.

BROOKLYN BRIDGE PARK

Stretching along the East River between the Manhattan Bridge and Atlantic Avenue, Brooklyn Bridge Park has transformed a narrow 1.3-mile stretch of neglected waterfront into the city's most dynamic urban green space. In the eighteenth and nineteenth centuries, the shoreline here was one of the busiest in New York, but after the Brooklyn and Manhattan bridges were built, trade dried up and the old piers gradually fell into disrepair. Work started on the park in 2008 and the first phase opened two years later, with development still ongoing. Features include sweeping lawns, riverside promenades, an antique carousel encased in a glass box—and, of course, knockout views.

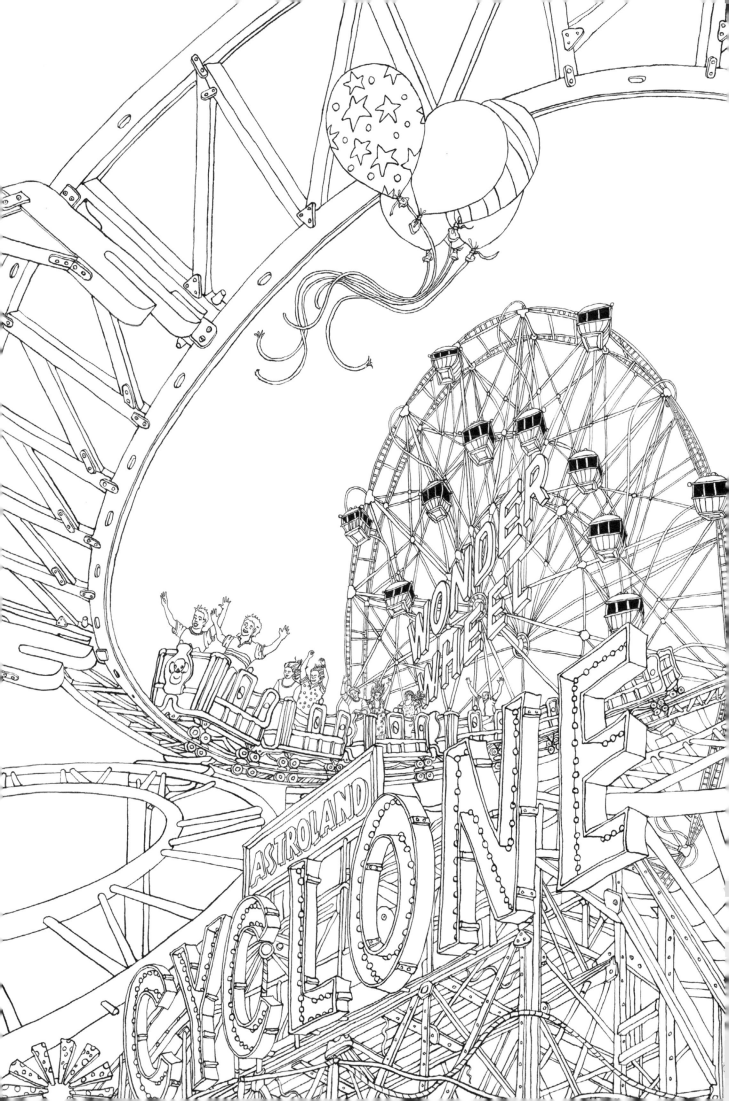

previous page

16.

CONEY ISLAND

Perched on a southeast corner of Brooklyn overlooking the Atlantic Ocean, Coney Island has undergone a renaissance over the last decade. Since 1829, when the first resort hotel opened, the area has been a popular day out from the city. The railroad arrived in the 1860s, followed by three major amusement parks: Steeplechase Park (1897), Luna Park (1903), and Dreamland (1904). Over the following century their fortunes, and those of their successors, rose and fell, but a number of the original attractions still remain, including the historic 1920s' Cyclone Roller Coaster and Wonder Wheel.

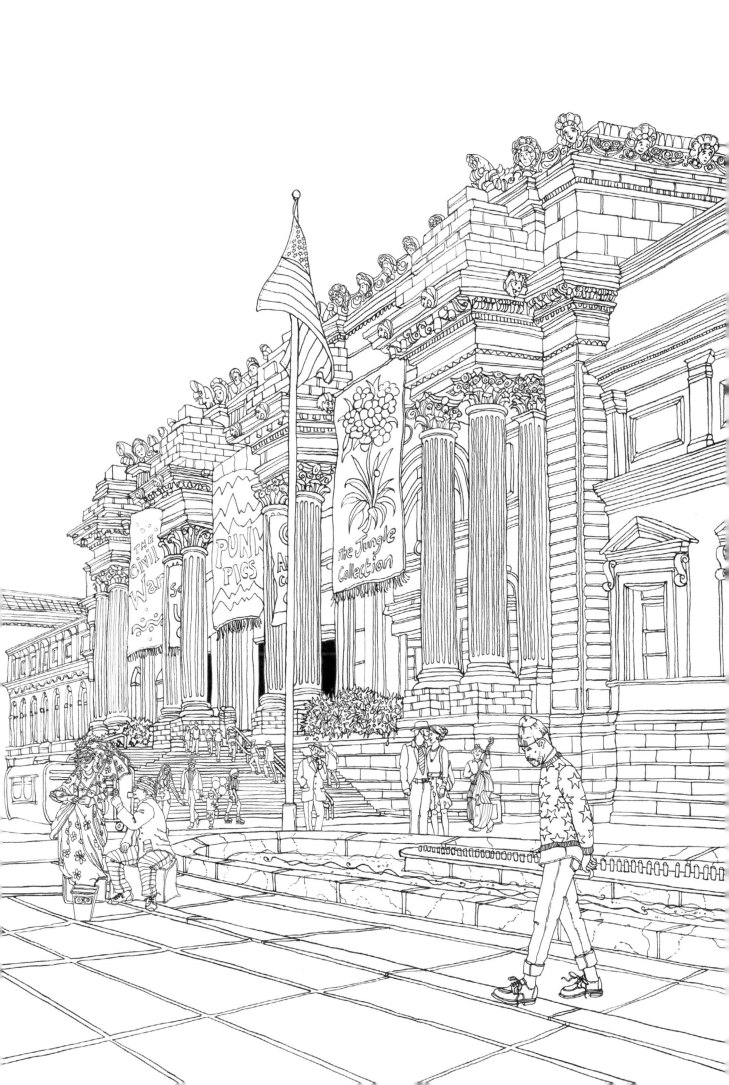

previous page

17.

THE METROPOLITAN MUSEUM OF ART

The Metropolitan Museum of Art was founded in 1870 by a group of eminent American philanthropists, collectors, and businessmen who had traveled in France and observed that their own country had nothing to compare with the French national collections in the Louvre. Today the Met (as it is colloquially known) houses more than two million objects and has some of the greatest collections in the world. It also hosts many of the high-profile exhibitions in the city on subjects ranging from Henri Matisse and Australian Aboriginal painting to the fashion designer Alexander McQueen.

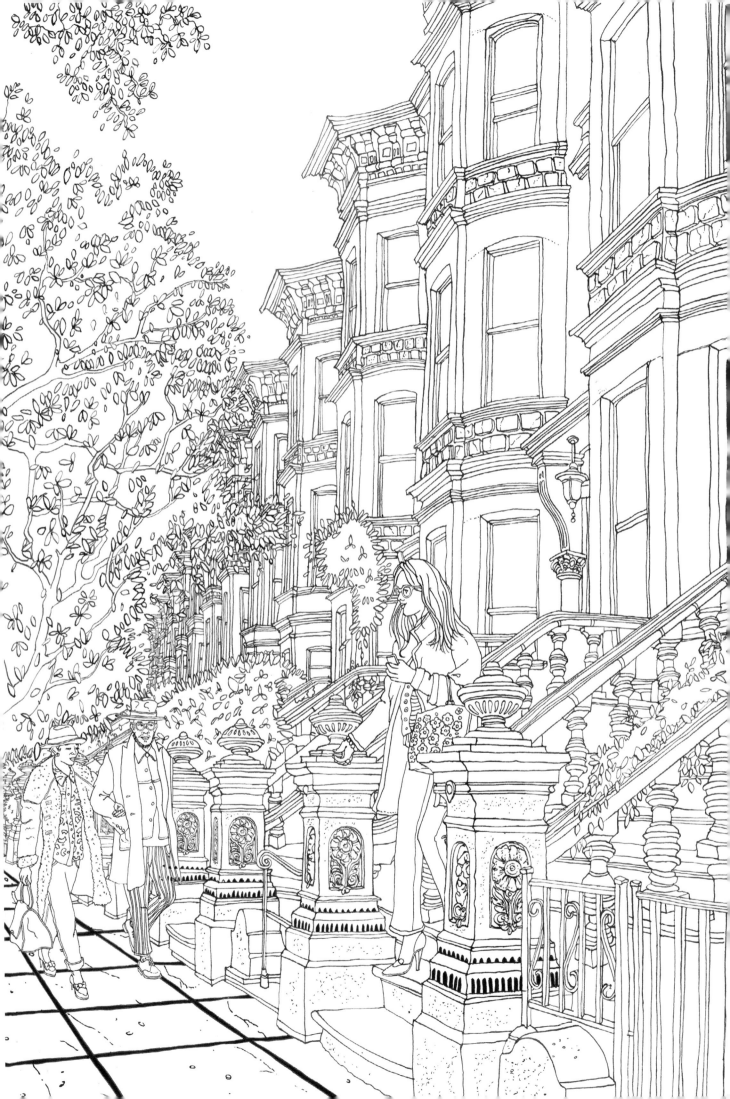

previous page

18.

BROWNSTONES IN BROOKLYN

Brownstones, usually brick-built nineteenth-century row houses faced with more expensive brownstone, are found throughout the city, but "Brownstone Brooklyn" has many of the most desirable and beautifully detailed examples. Times have changed for this borough that has traditionally been looked down on by Manhattanites: the town houses' popularity—and increasingly huge price tags—are the most tangible signs of both the gentrification and the cultural renaissance that have taken place over the last decade.

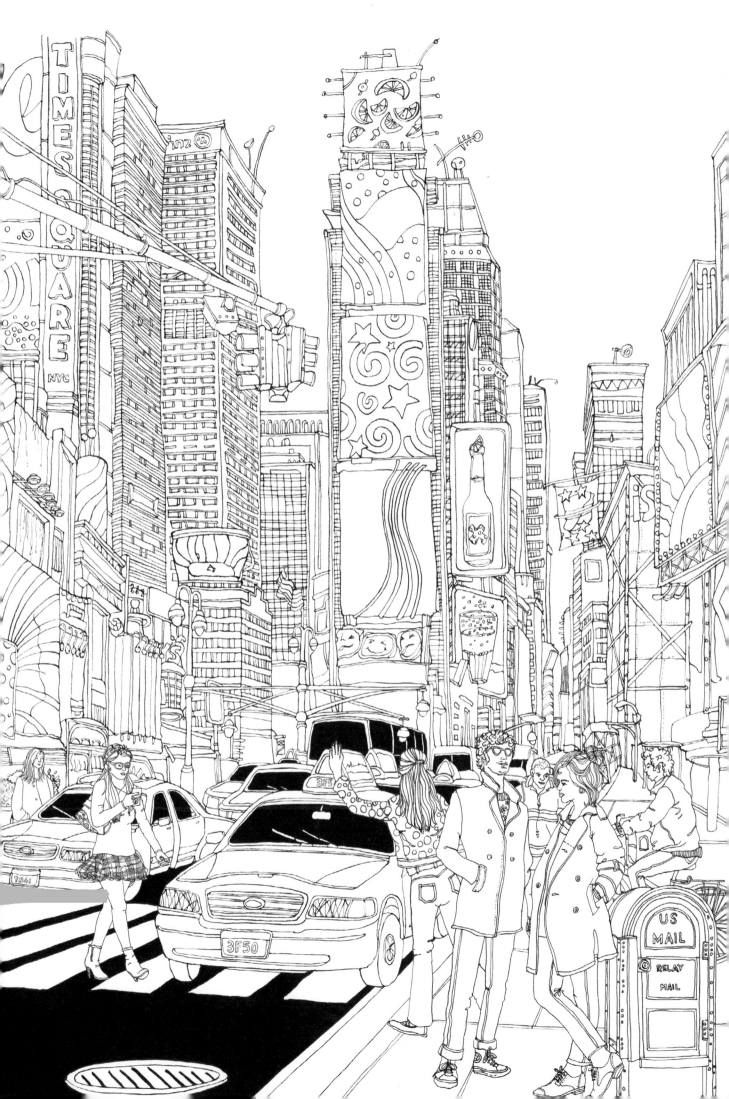

previous page

19.

TIMES SQUARE

Times Square, originally Longacre Square, was renamed in 1904 when the *New York Times* moved into a new building on 42nd Street, at the junction of Broadway and Seventh Avenue. In 1907, the newspaper's owner, Adolph Ochs, started the tradition of the city's New Year's Eve "ball drop" as an alternative to his fireworks display that had been declared illegal. Today huge crowds assemble in the square every year to see the illuminated ball on top of the Times Tower drop 141 feet down its pole between 11:59 and midnight—encouraging the audience to count in the New Year.

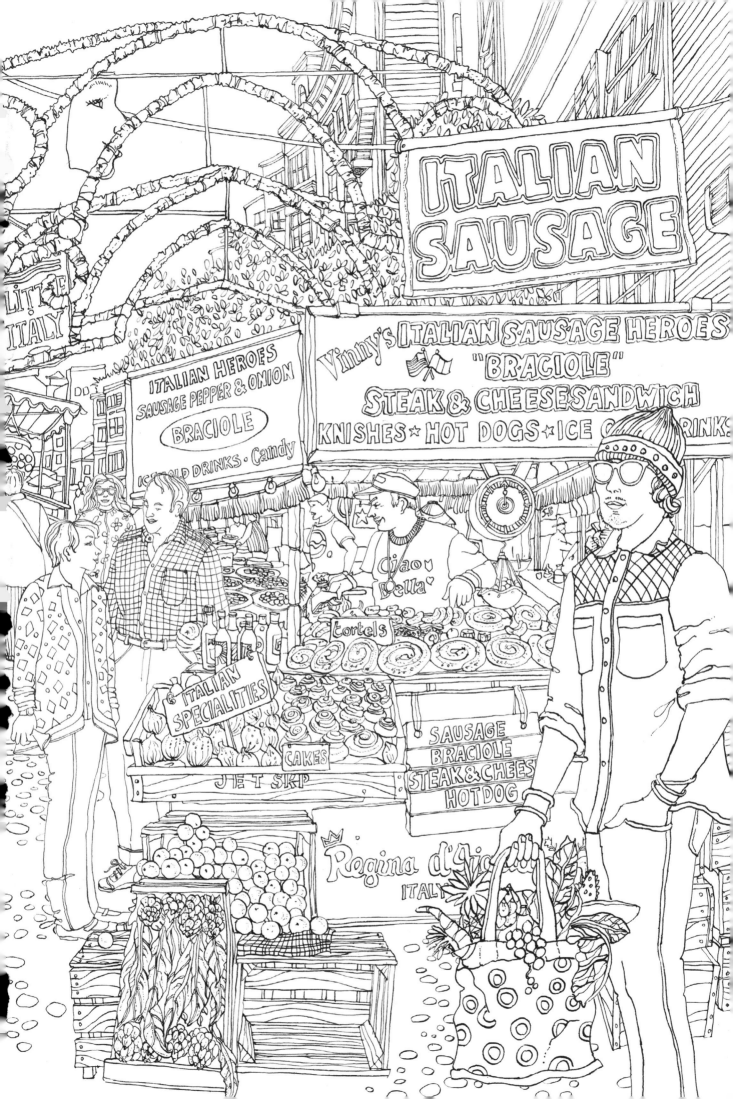

previous page

20.

THE FEAST OF SAN GENNARO, LITTLE ITALY

Running for ten days in September, the Feast of San Gennaro takes over a large chunk of Little Italy, with stalls lining parts of Mulberry, Grand, and Hester streets. The feast was first marked here in 1926, when homesick Neapolitans gathered to celebrate their patron saint's day, September 19. The one-day festival gradually became an extended fair, featuring marching bands, a grand procession with floats, a smaller religious procession of the saint's statue, and a huge number of Italian delicacies such as zeppole and salsiccia alla pizzaiola. Also included are annual Italian-themed feats of skill, such as the attempt in 2014 to make the world's largest cannoli.